Welcome to the world of flowers!

Discover the magic and beauty that each flower brings. Immerse yourself in this wonderful world and unleash your imagination as you color these exquisite images. Let's create a garden of joy and vibrant colors together! Flowers are the vibrant paints of nature, each one a miniature watercolor masterpiece. By coloring these images, you not only express your feelings and inspiration on paper but also enrich your inner world. Dive into every moment of this creative process and let your brushes dance on the page, creating unique melodies of color. May each stroke be a step towards cultivating a garden of pure joy and inspiration, filling your day with bright colors and positive emotions."

best regards.Ana

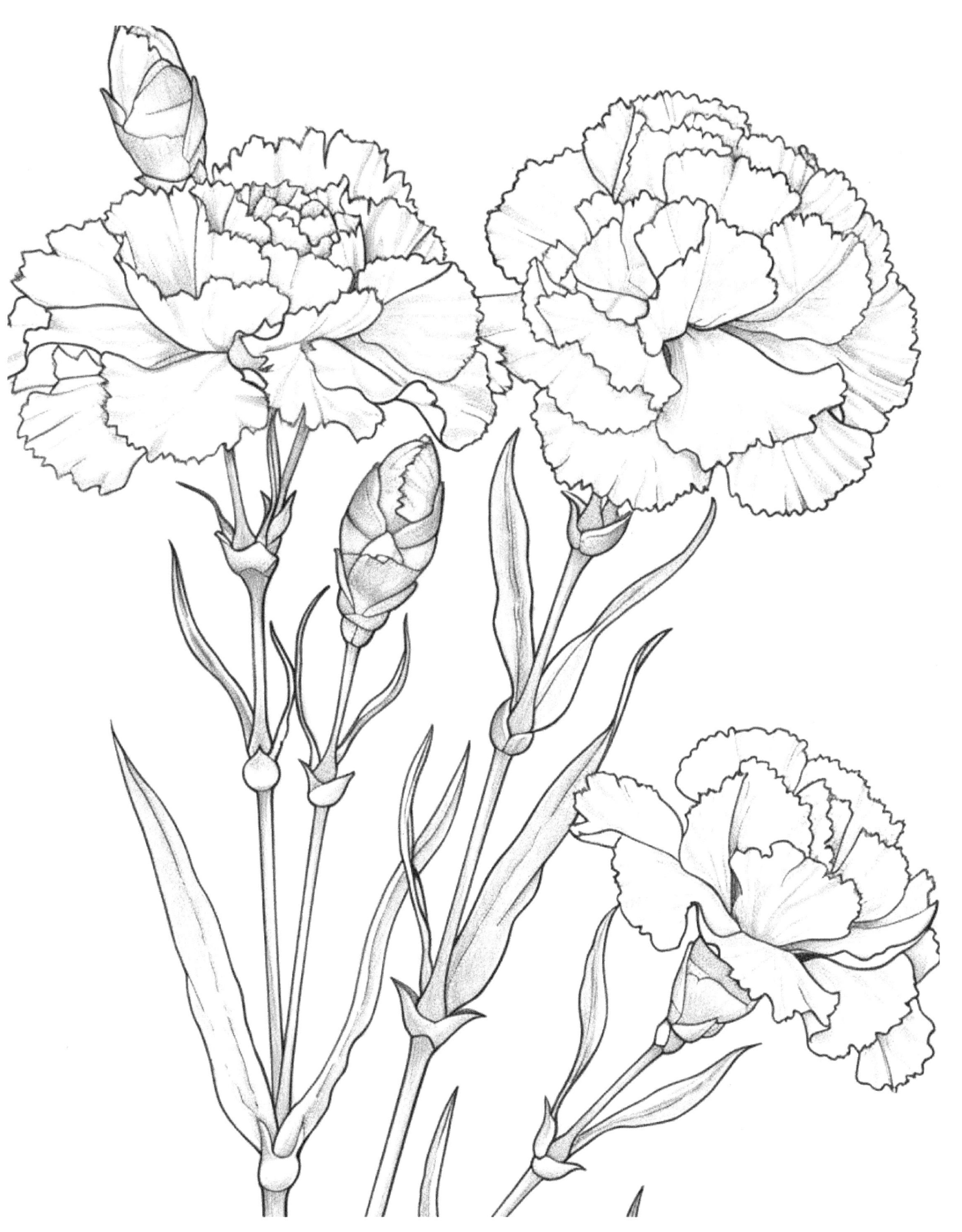

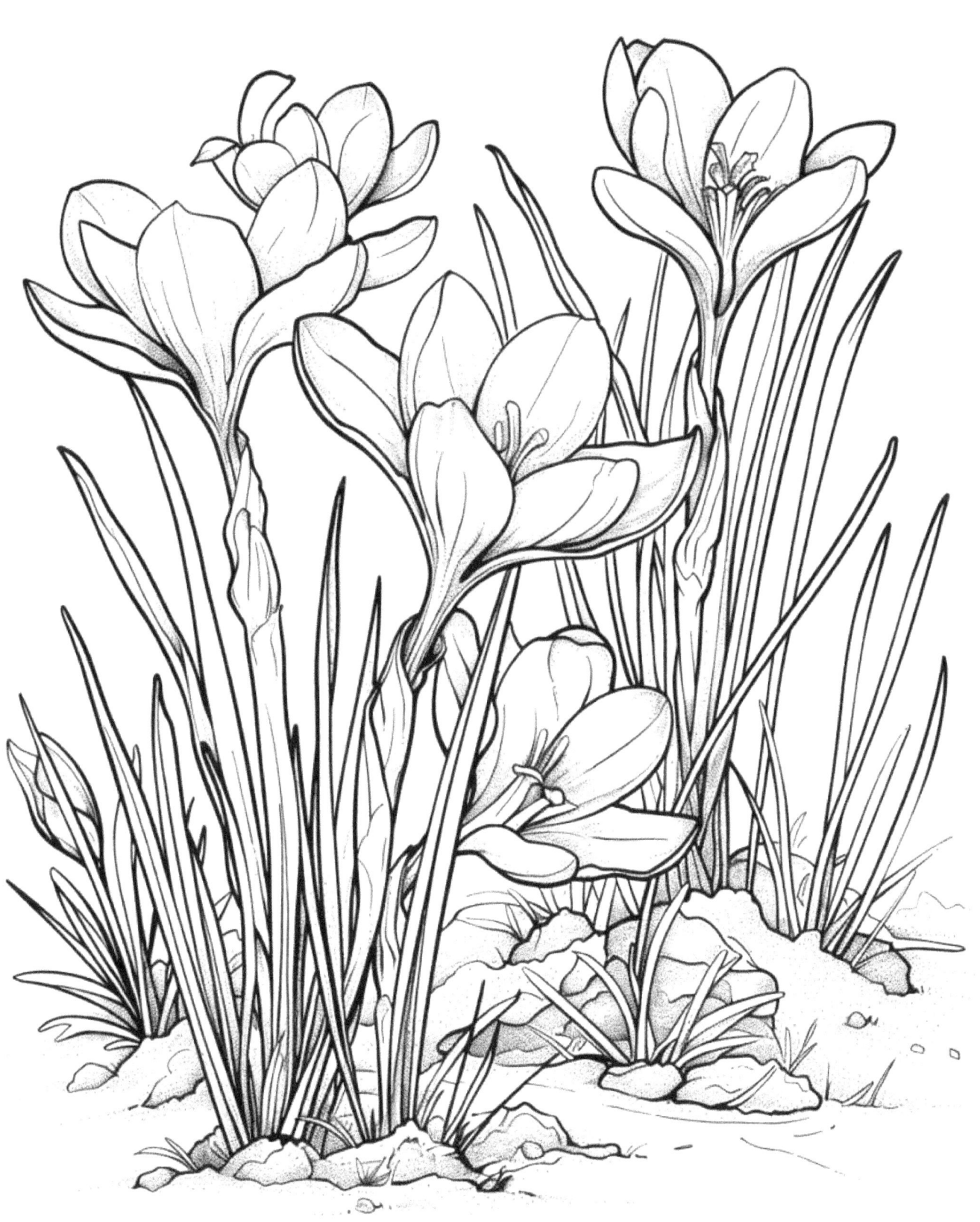

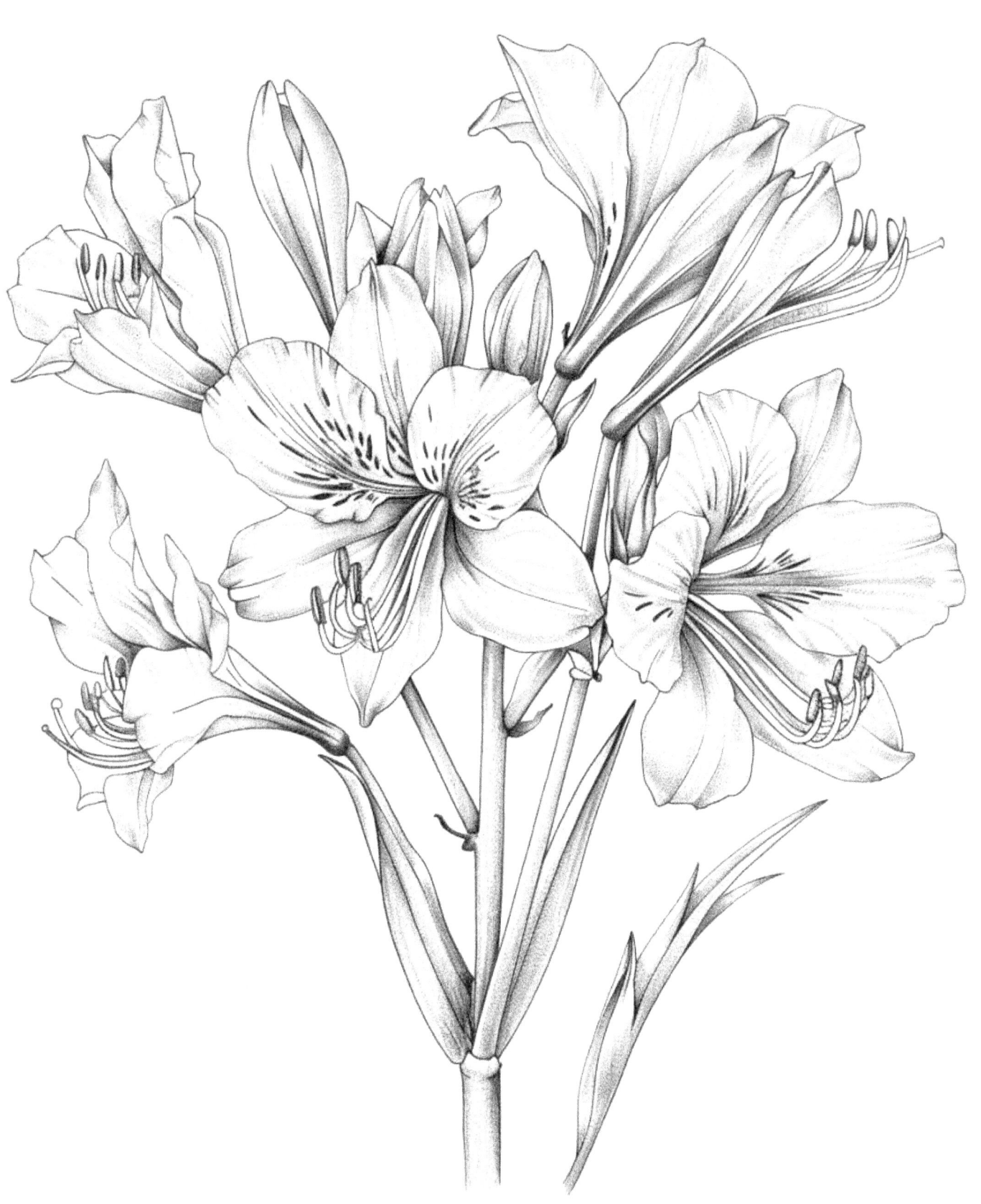

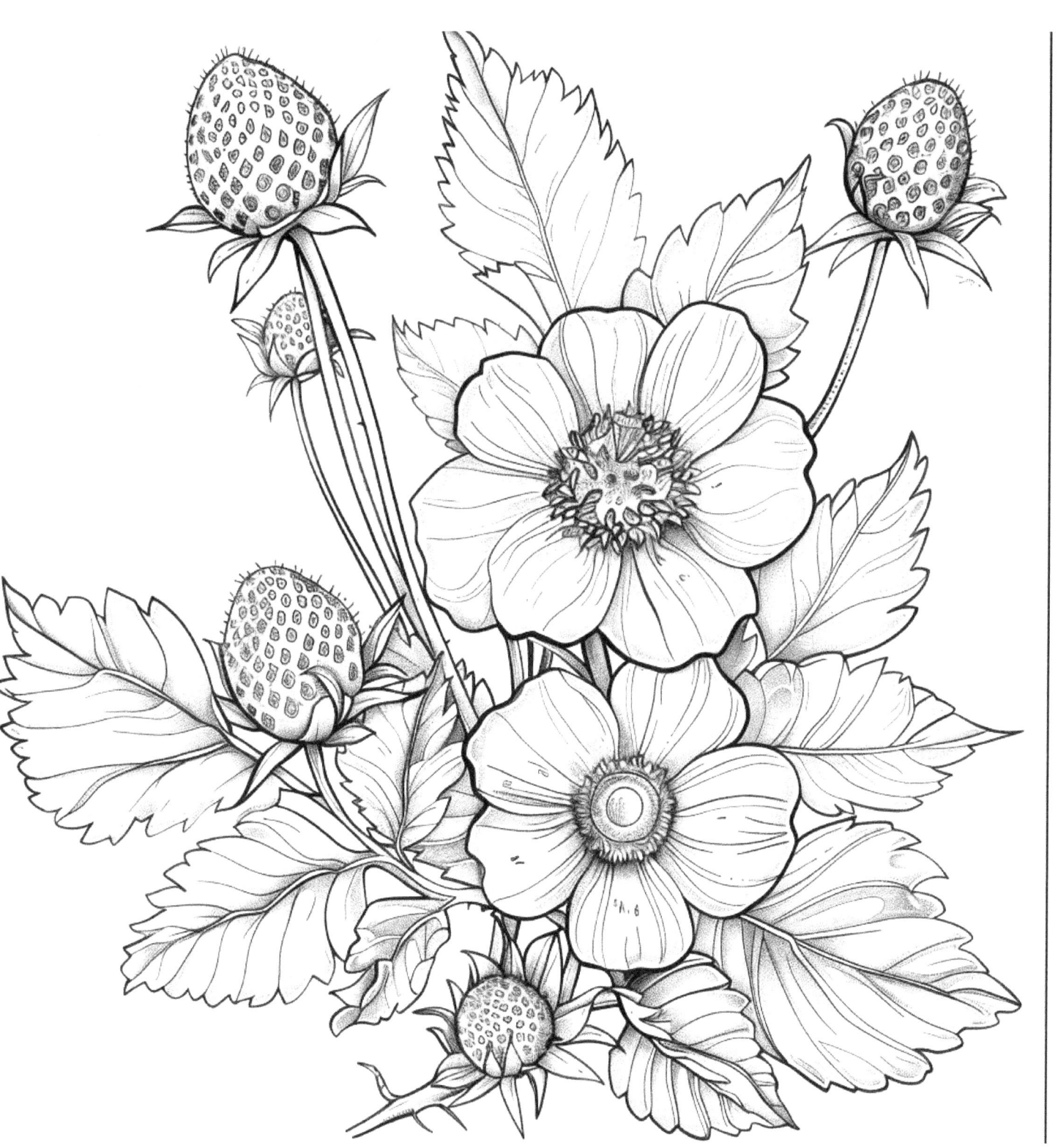

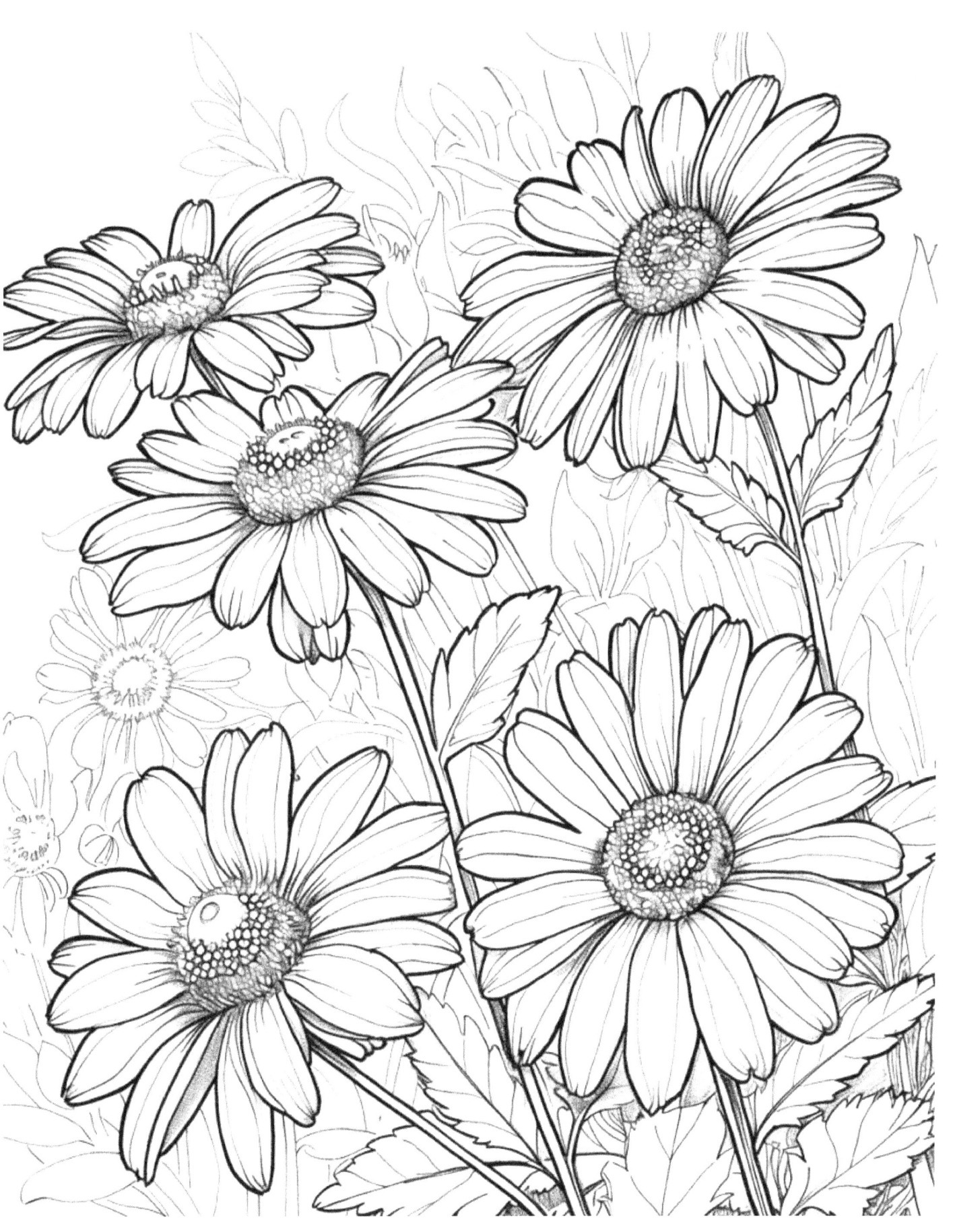

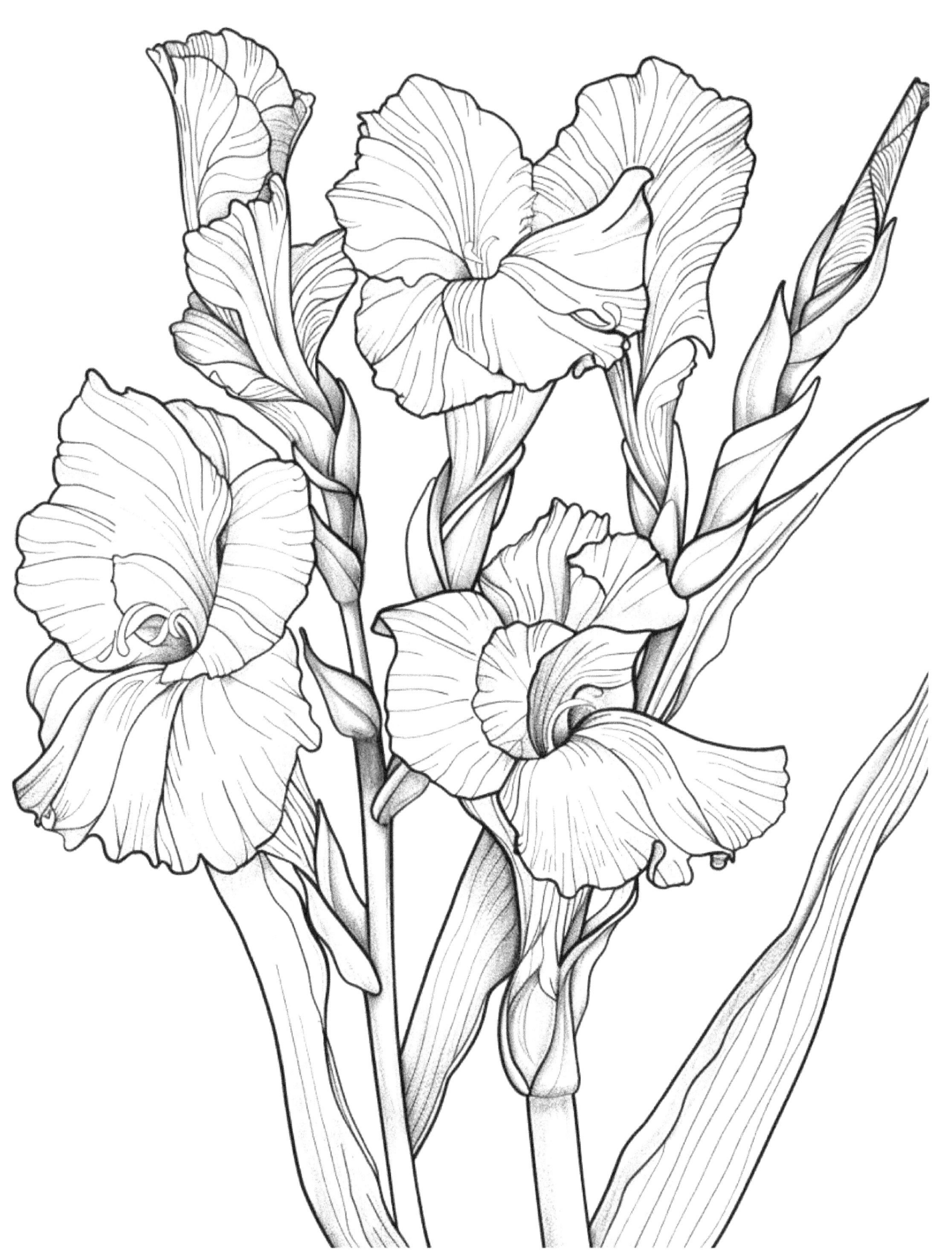

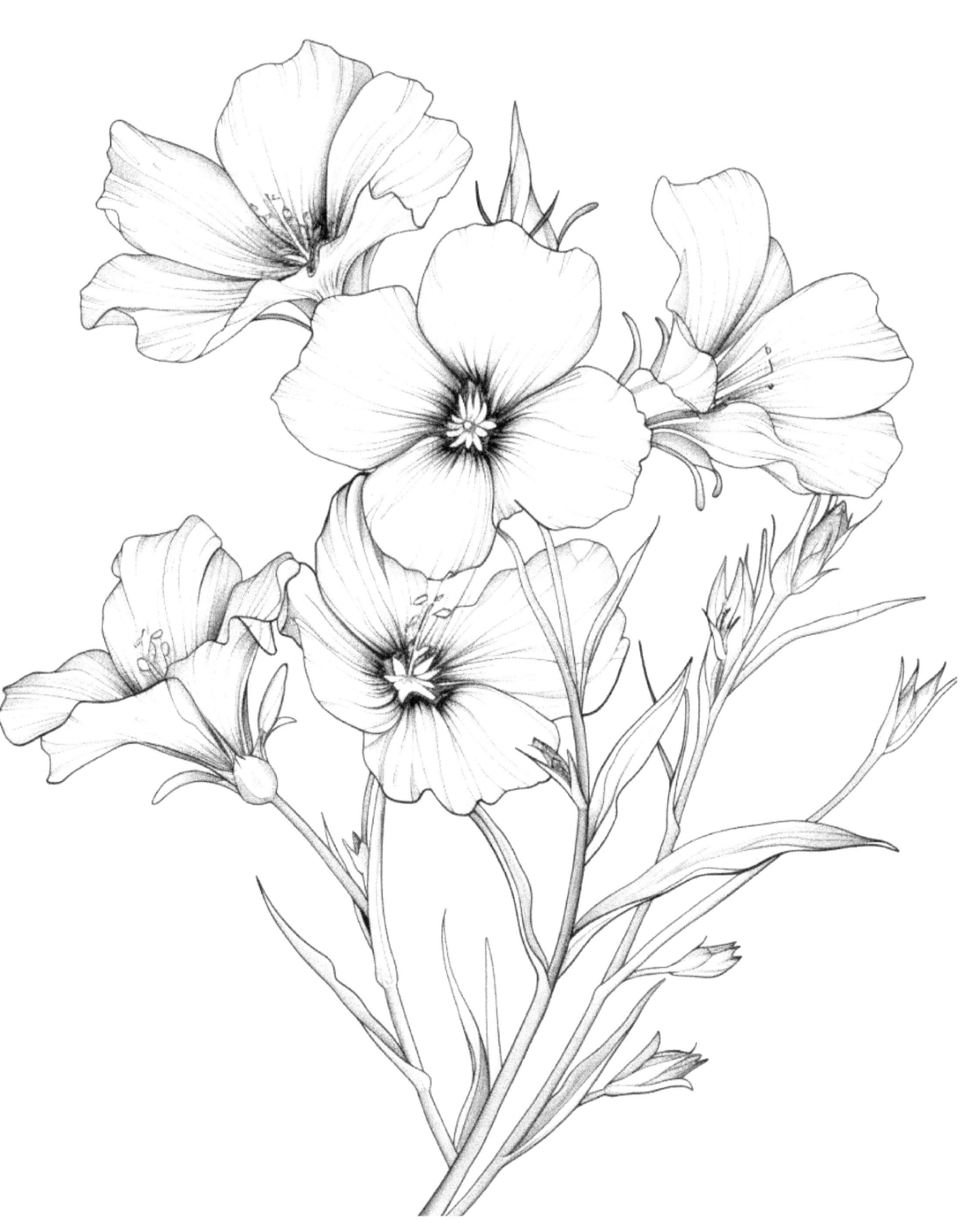

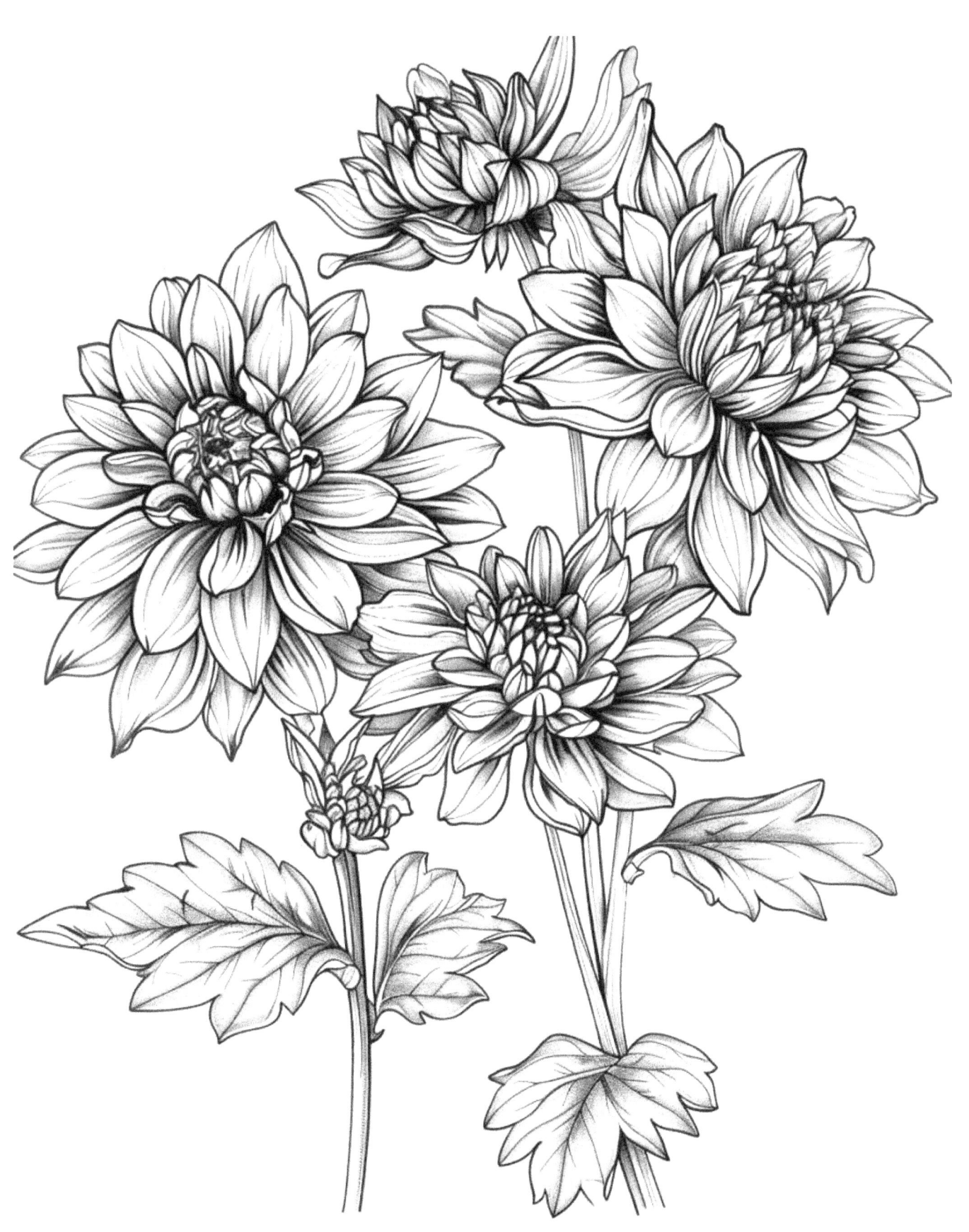

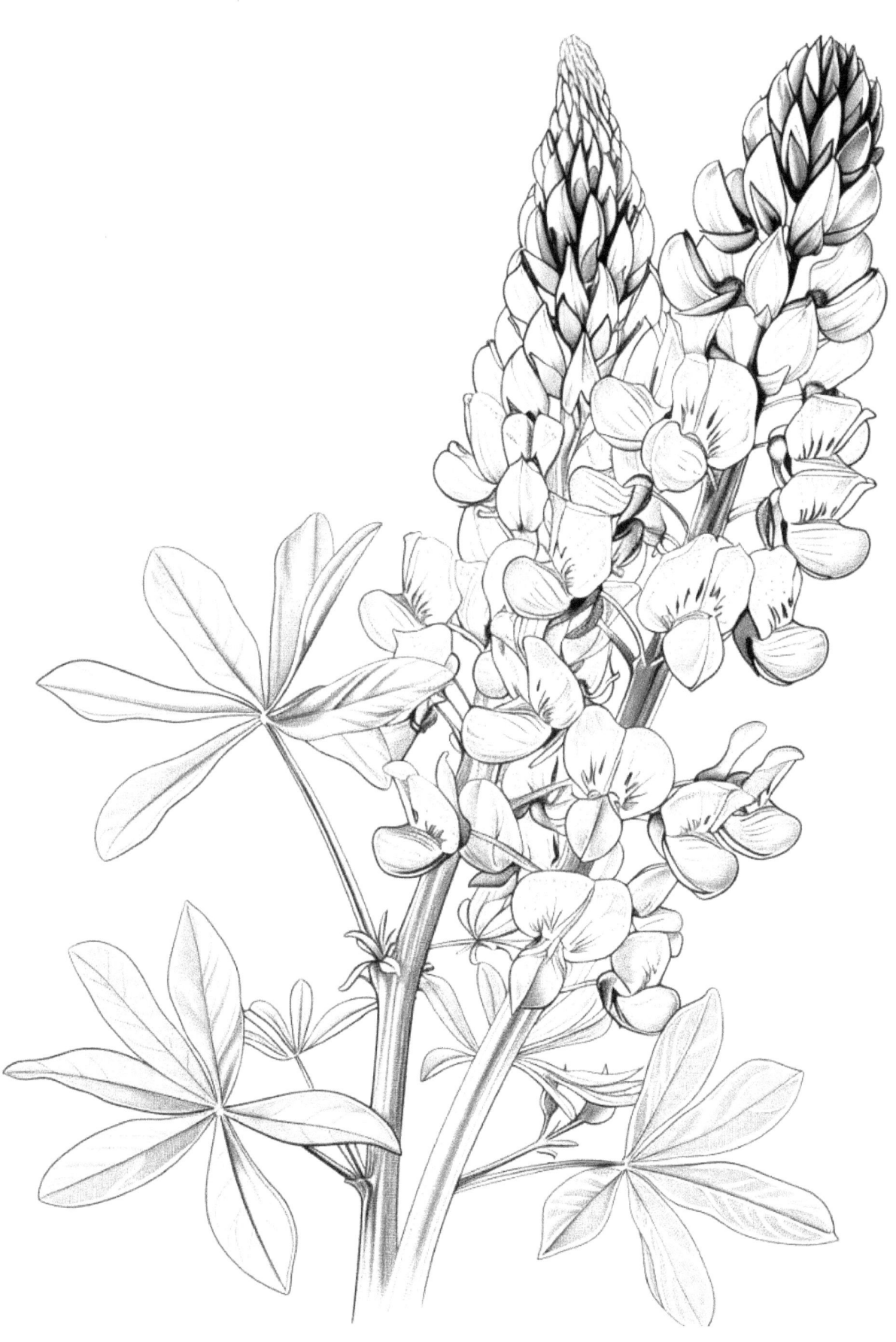

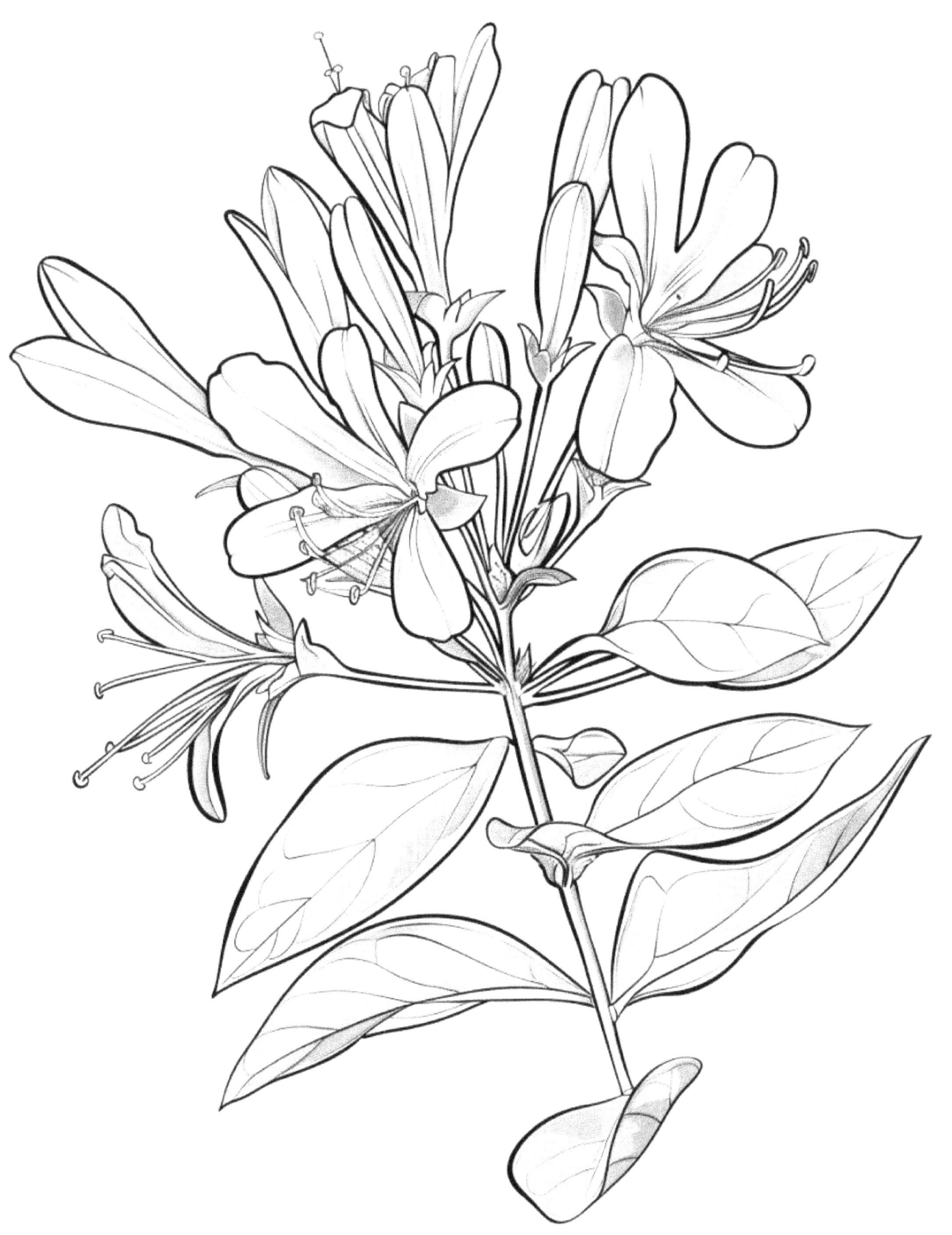

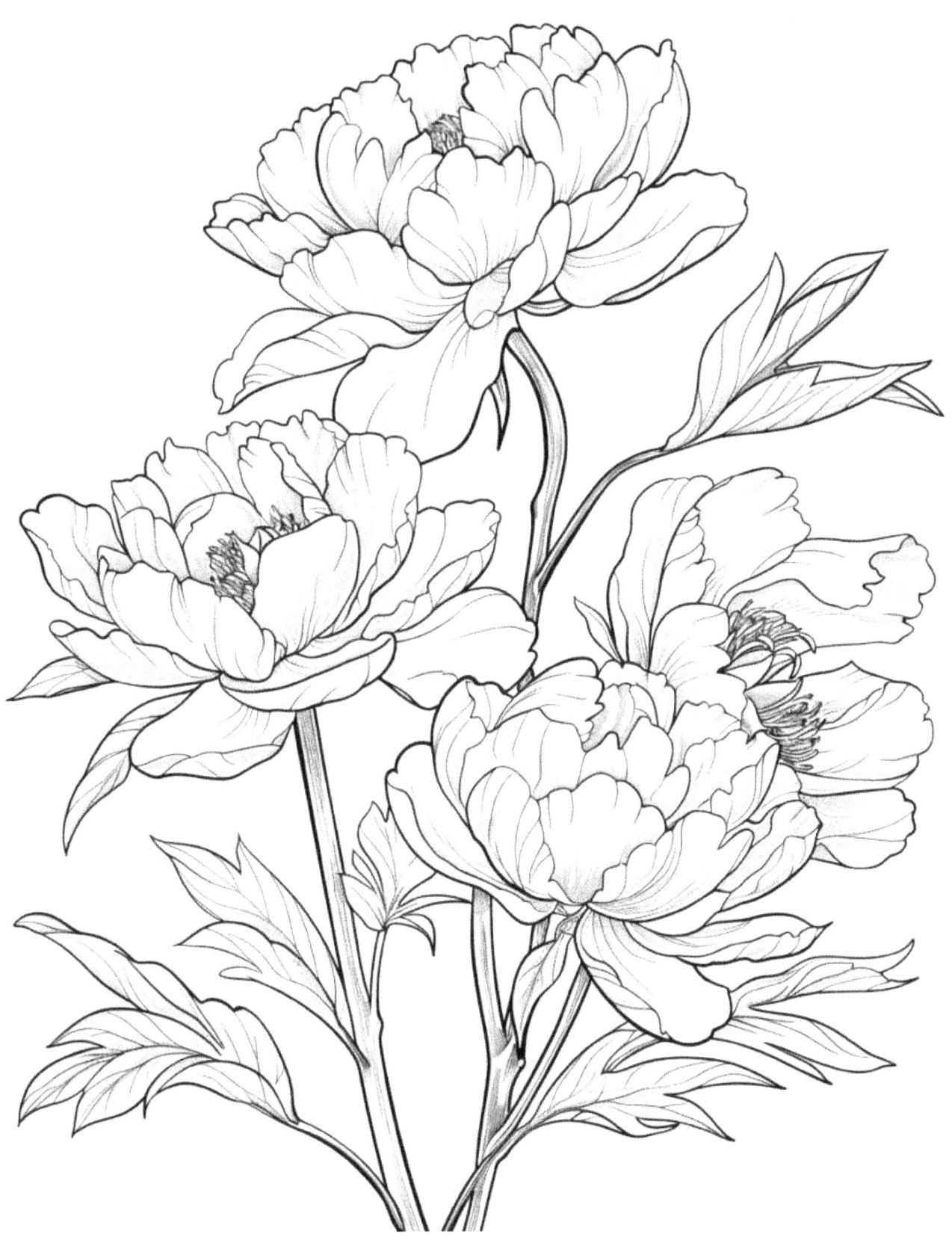

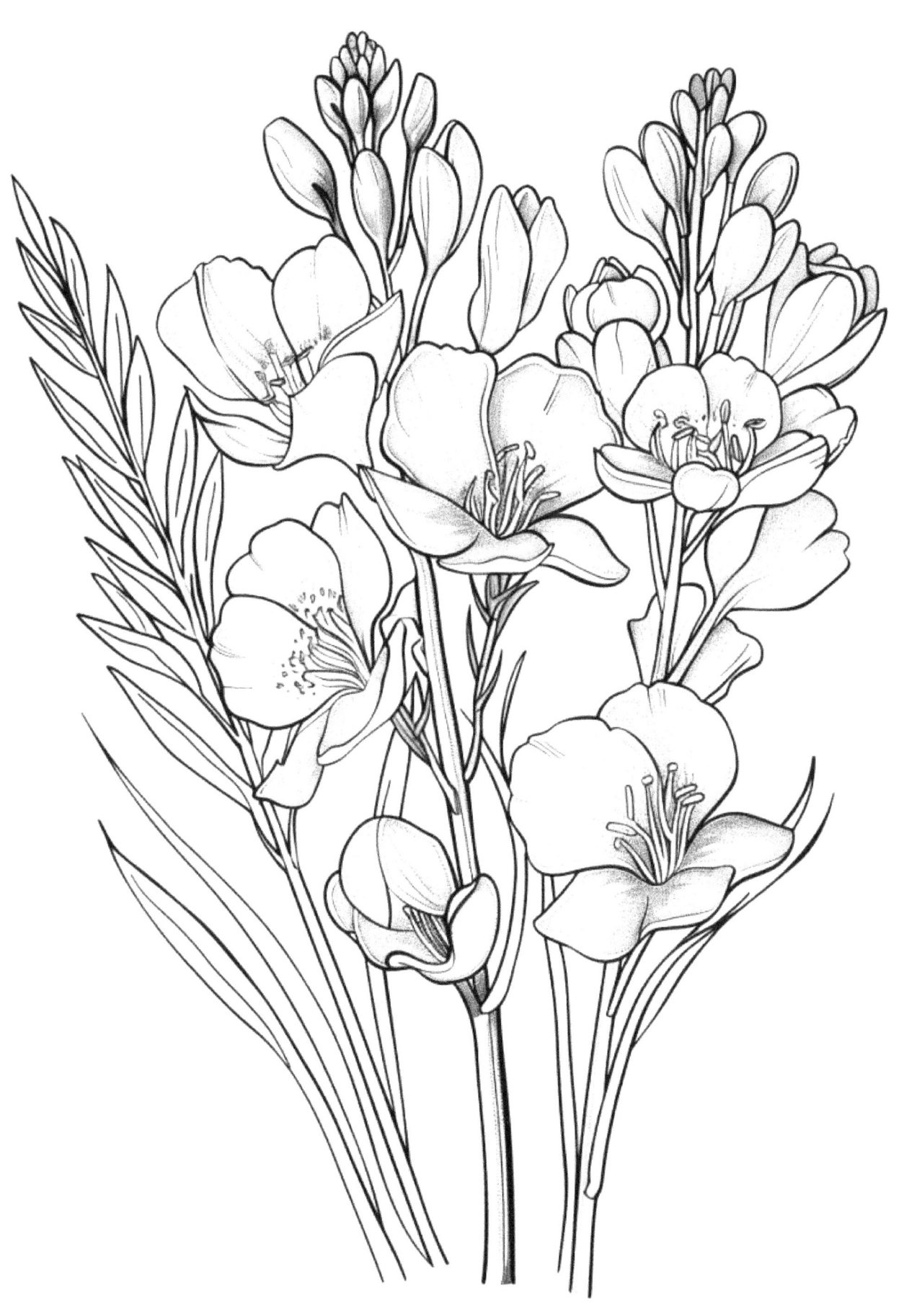

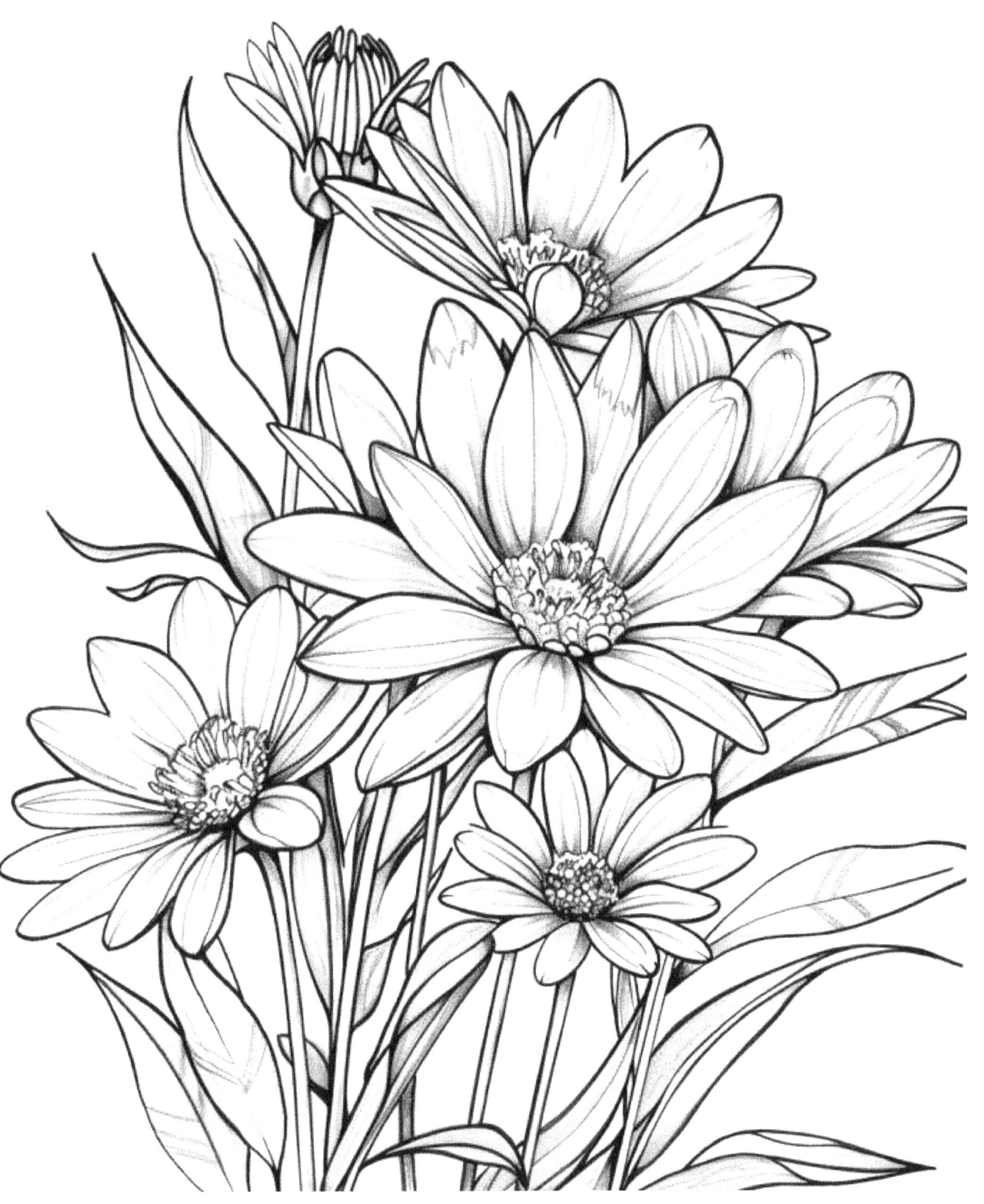

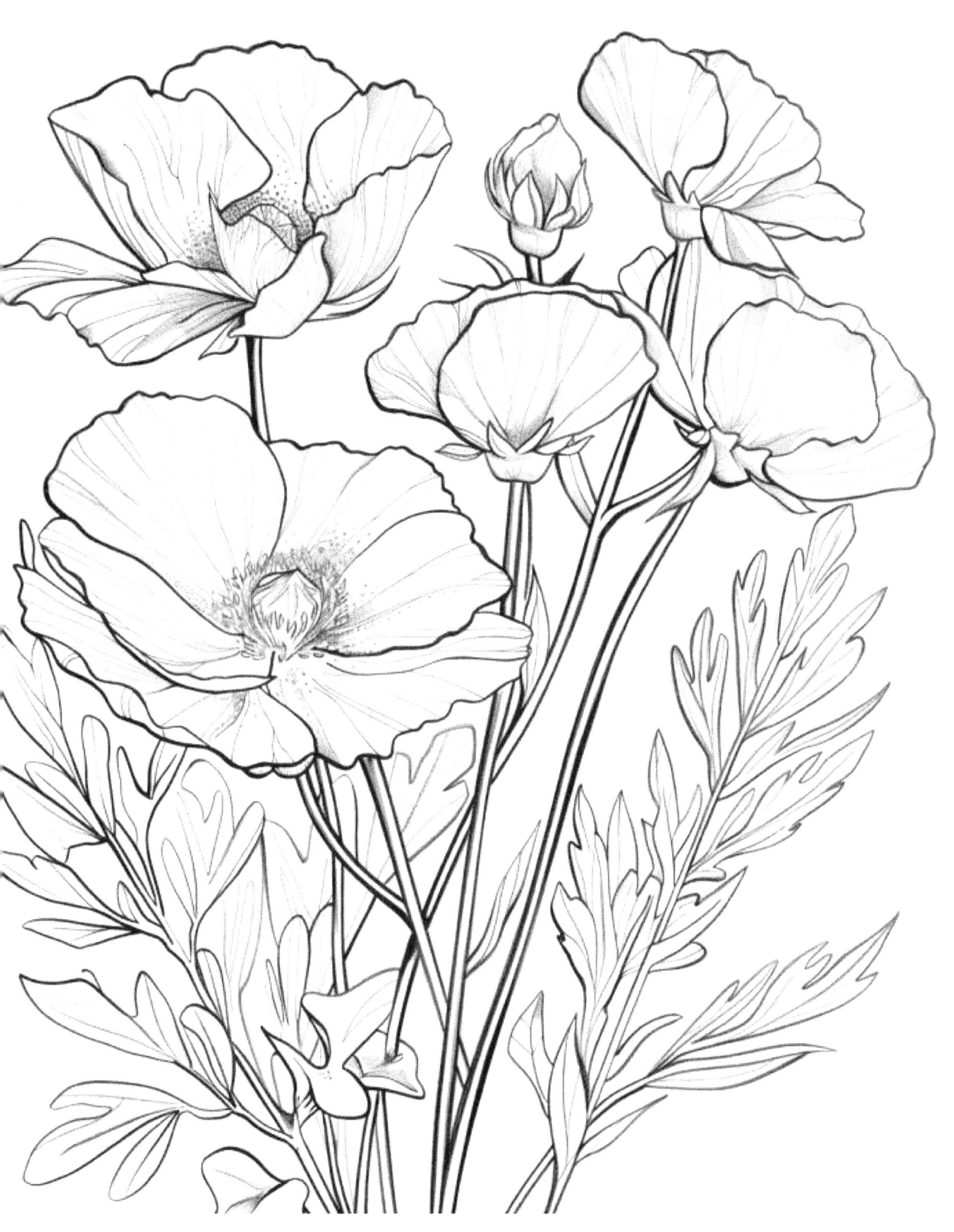

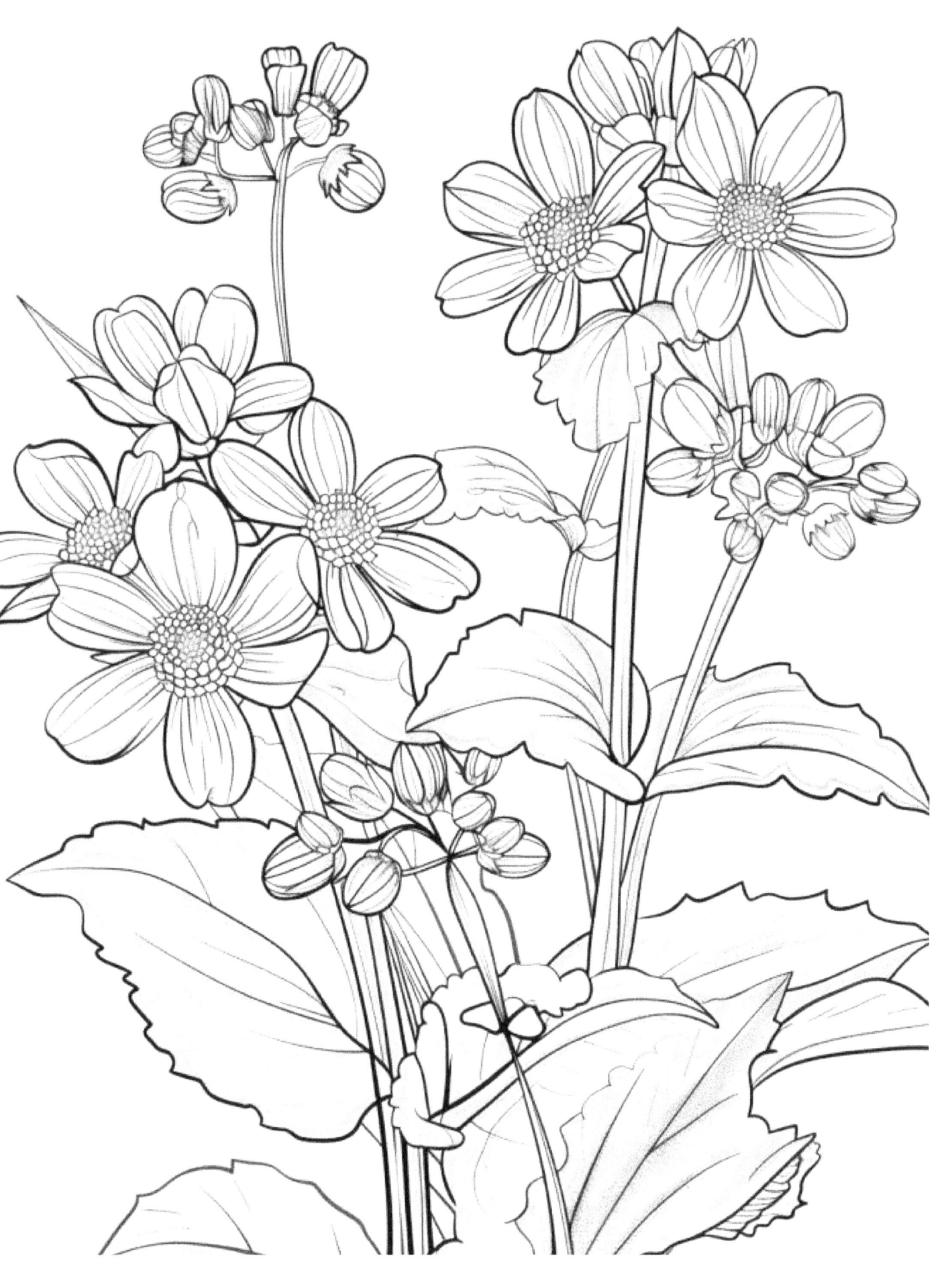

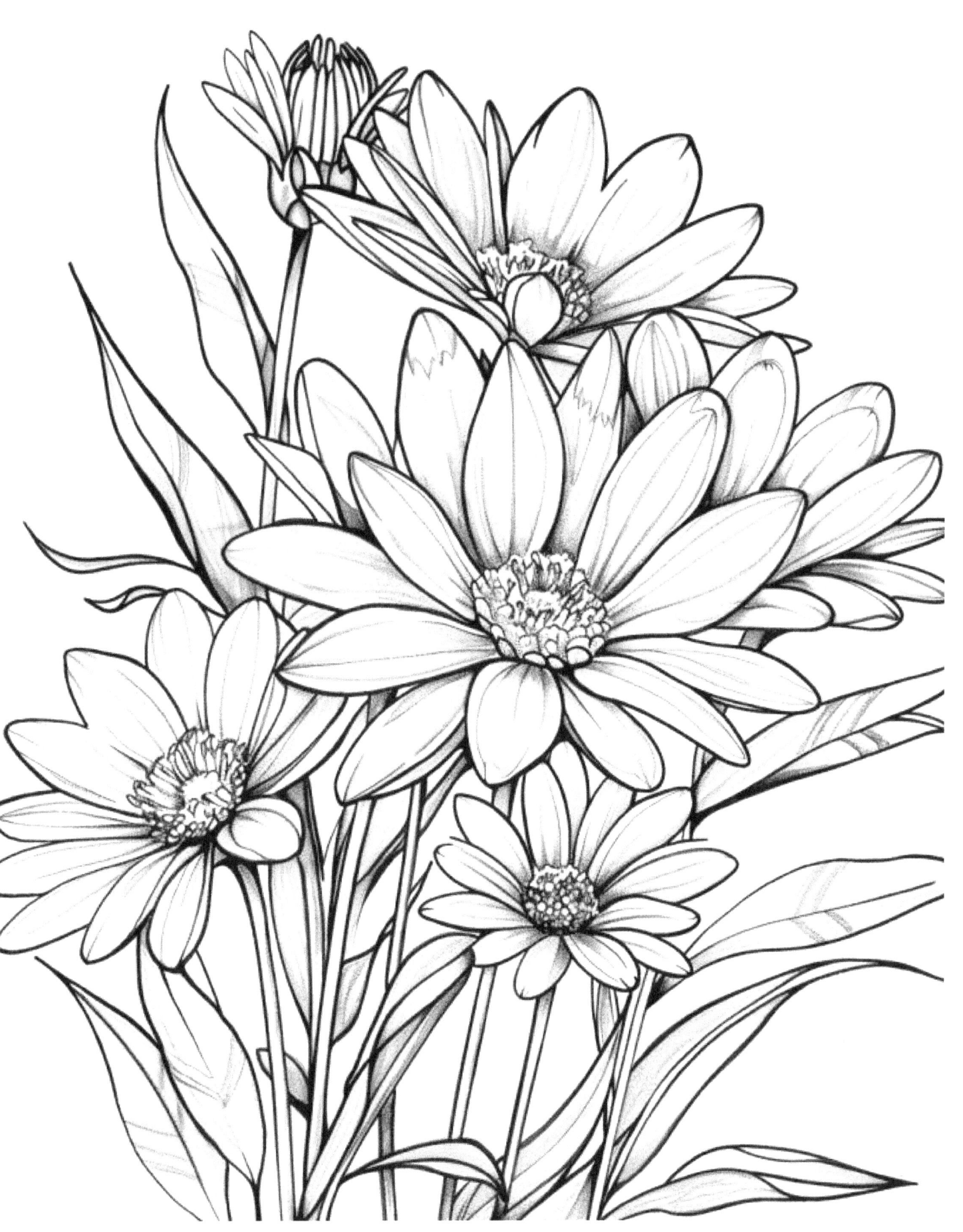

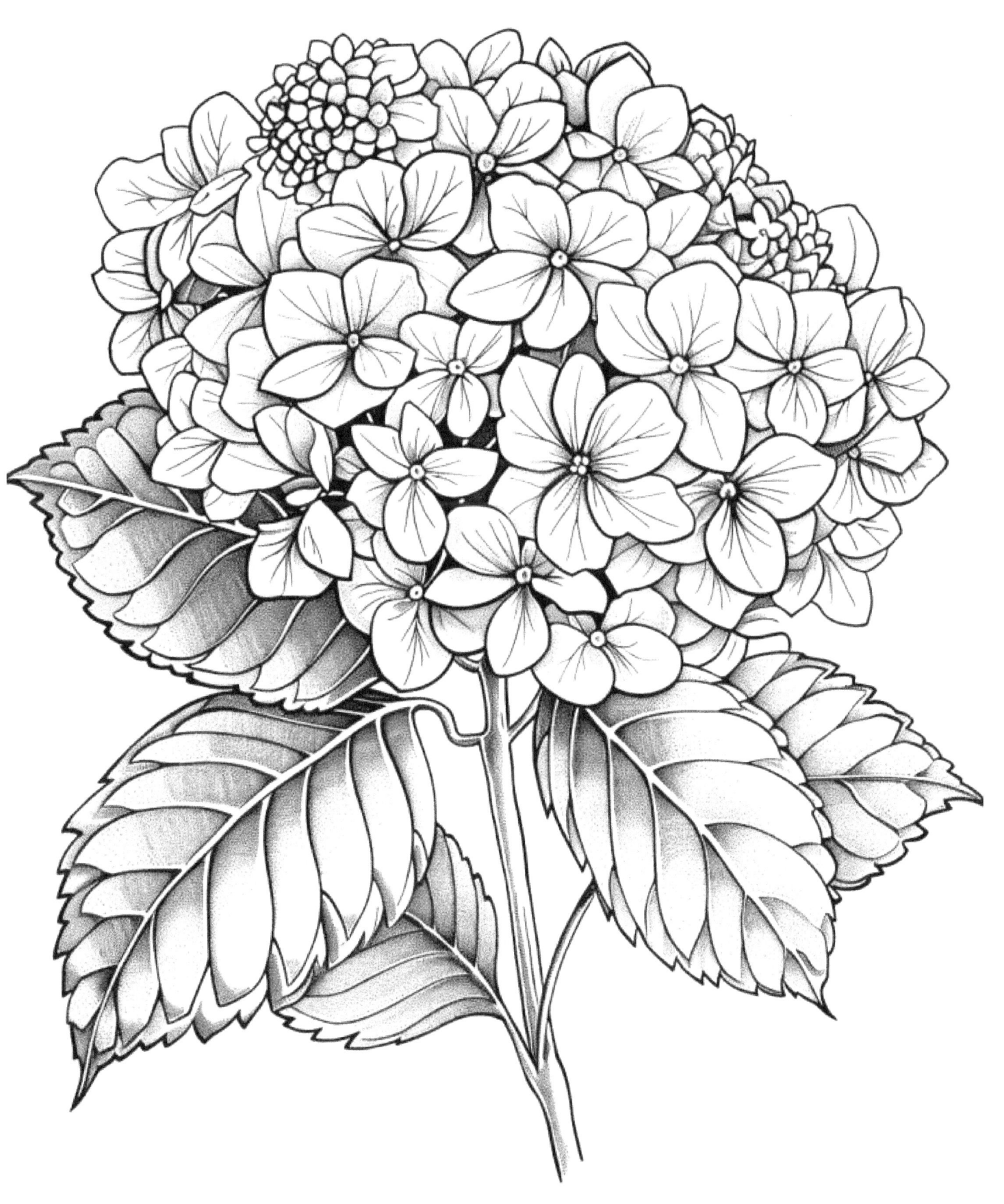

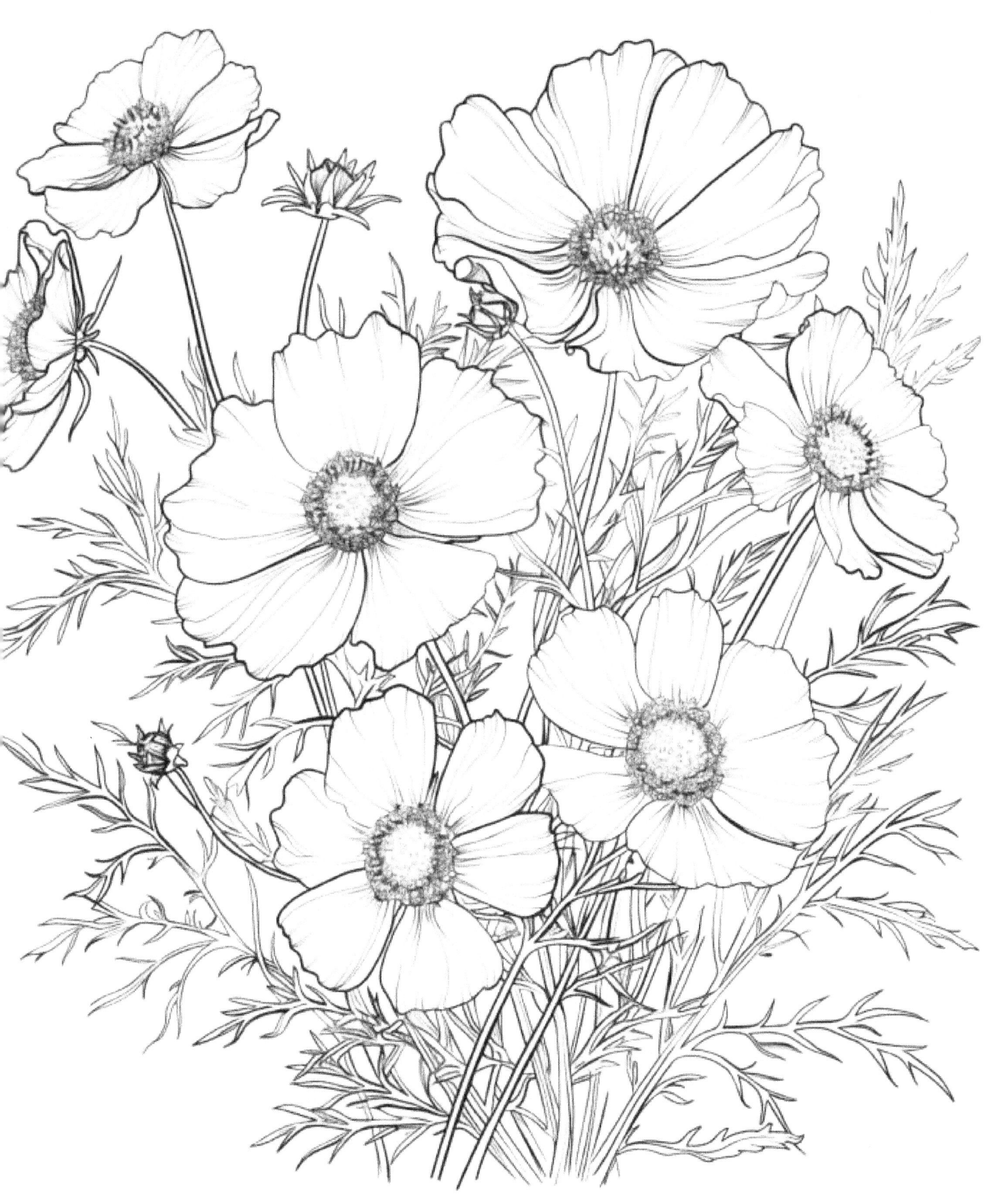

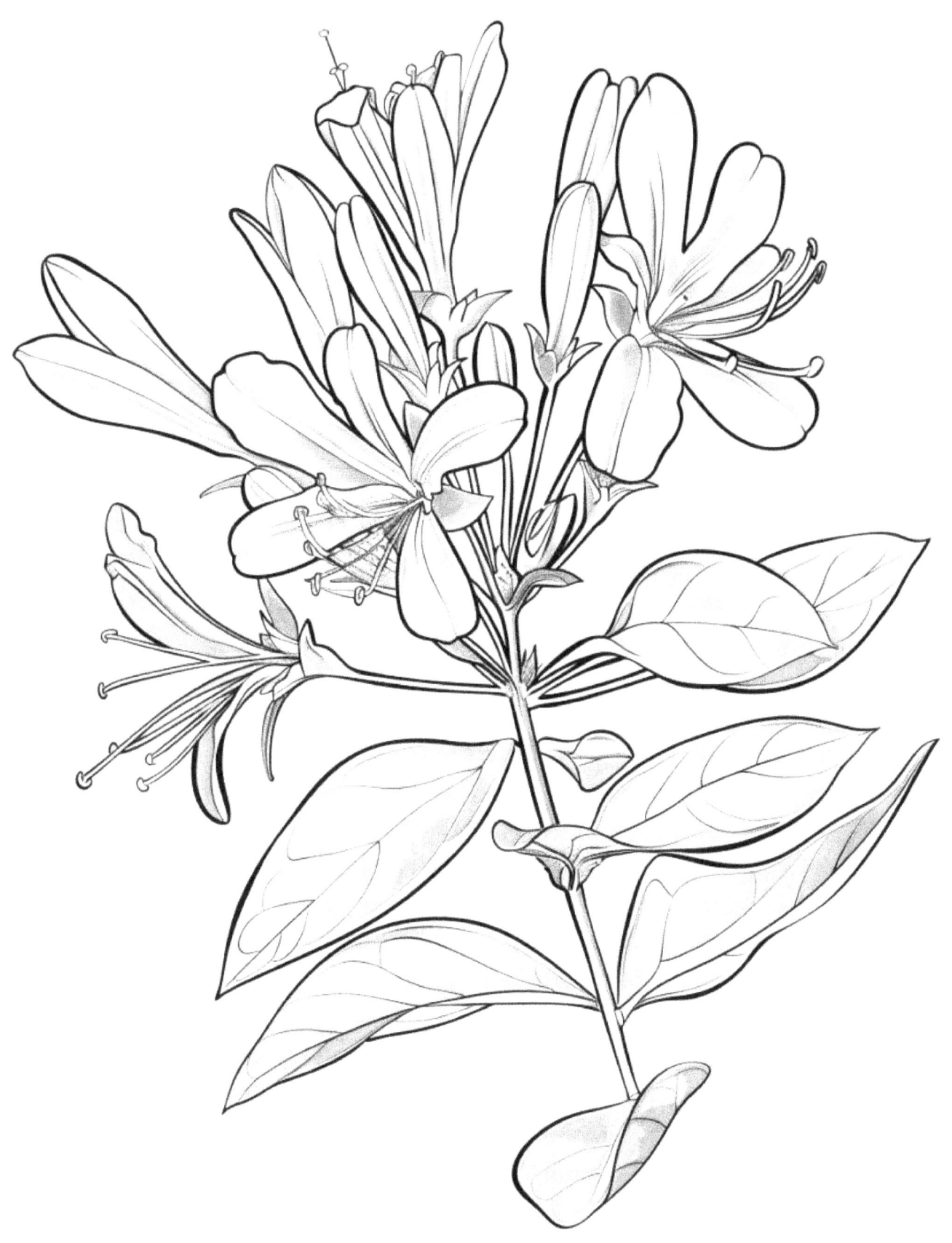

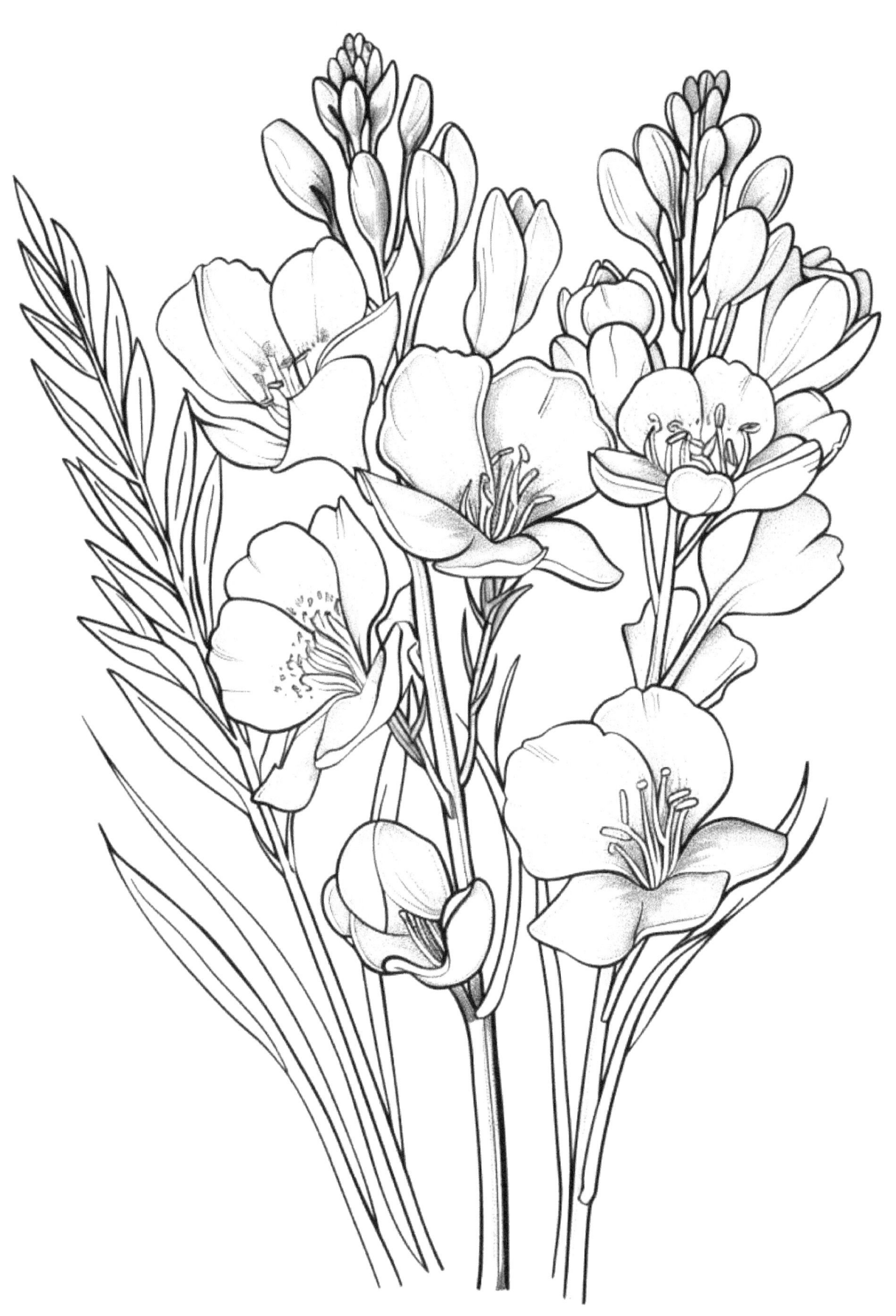

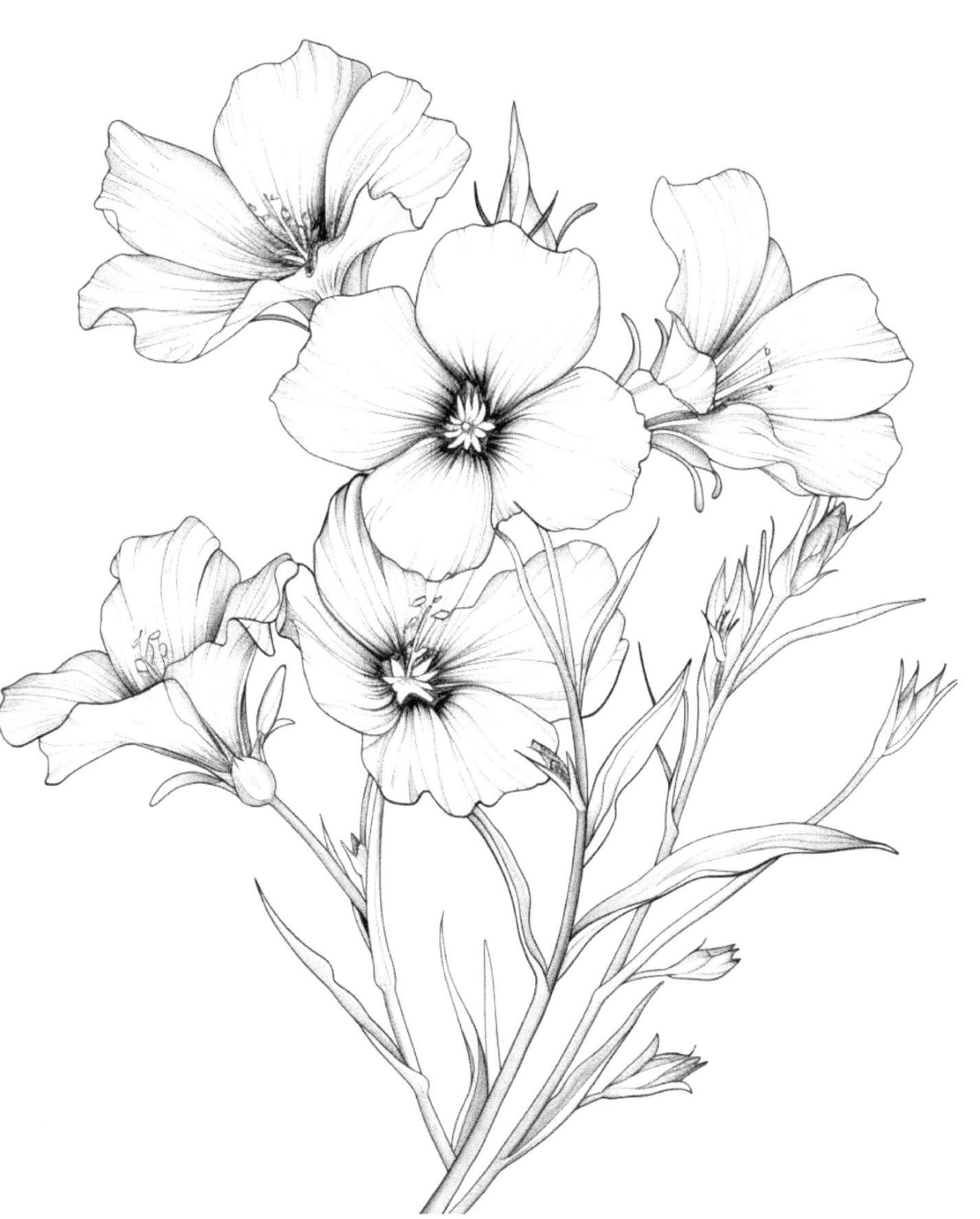

Congratulations!
You've completed your creative journey through the world of flowers. We hope each flower you colored brought you joy and inspiration. Remember to cherish the beauty around you and let flowers adorn your world every day!"

Best regards, Ana

www.ingramcontent.com/pod-product-compliance
Lightning Source LLC
Chambersburg PA
CBHW062314220526
45479CB00004B/1162